Squiggle Art

KIDS ART ACTIVITY BOOK

Copyright © 2019 Anna Nadler
All rights reserved
Published by Little Birdie Press™
No part of this publication may be
reproduced, stored in a retrieval system or
transmitted in any form or by any means,
electronic, mechanical, photocopying, recording
or otherwise, without prior written permission
from the author/publisher.
www.annanadler.com

Dear artists,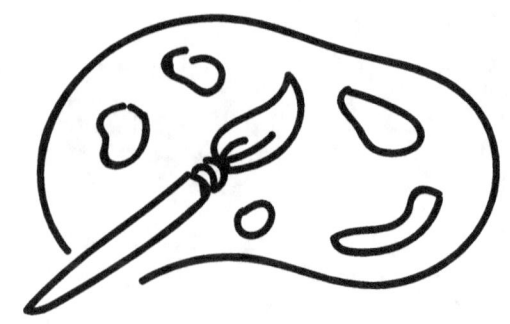

Squiggle art is something I got introduced to as a child, by my mom. It is an artistic and cognitive game designed to develop one's imagination. It is also designed to provide an outlet for a person's creative expression through drawing.

After all, art is one of the best forms of creative SELF-EXPRESSION!

Don't be afraid to make a mistake, don't hold back. Think about more than one way you can solve a problem.

This book will encourage you to develop your own artistic style and to teach you to draw often and creatively.

It contains many drawing prompts for you to finish the drawing in any way your imagination allows.

You are encouraged to be free to create any picture you see. You can even combine different lines to form unique compositions! So, relax, have fun, and enjoy many hours of creating art! Animals, plants, storybook characters, and anything else you can see in your imagination!

COMPLETE THE DRAWING

Use a different color pen or crayon to finish the picture
Use your imagination!
When drawing, the only rule is, do not touch or draw on top of the original line!

EXAMPLE

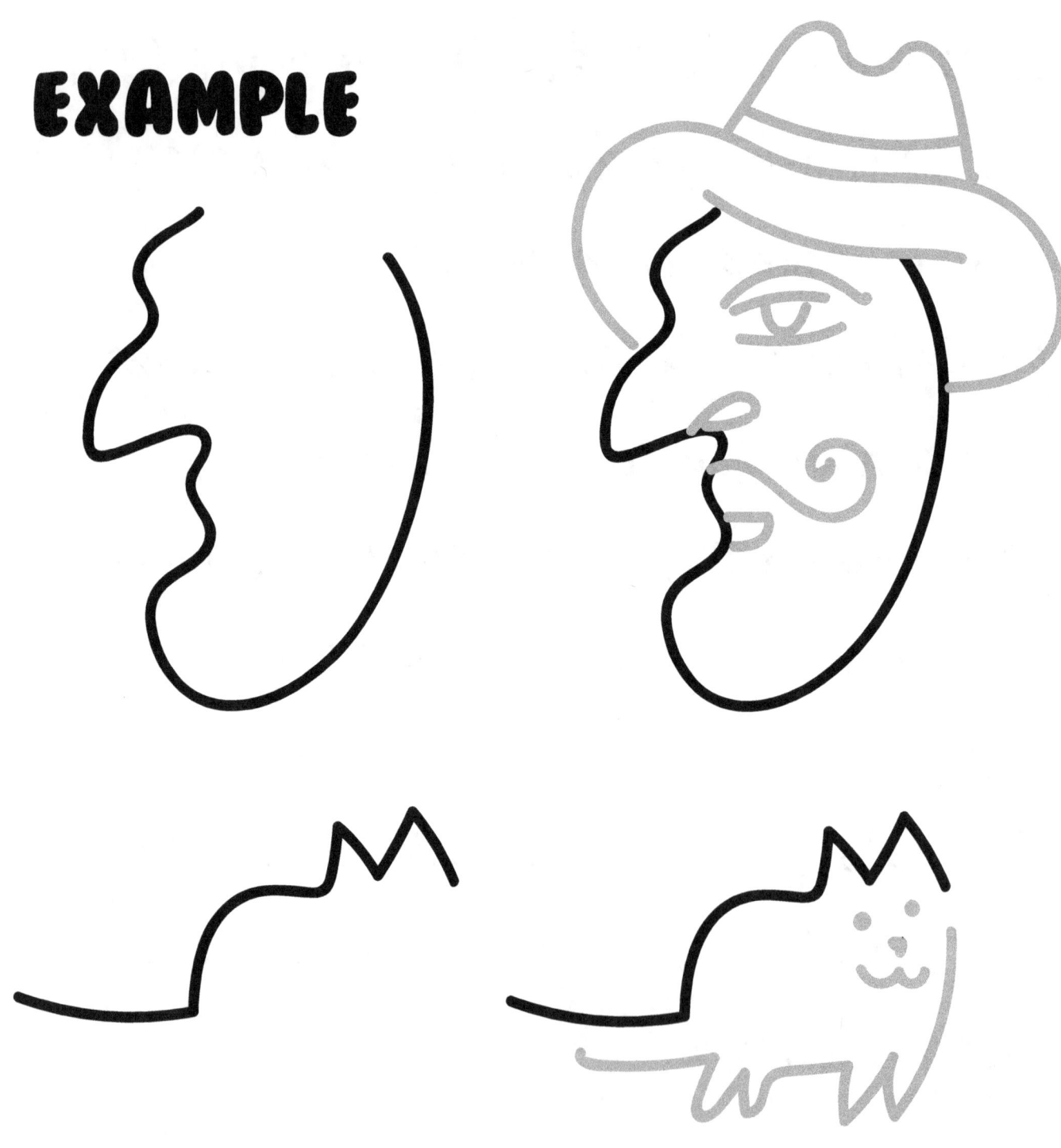

COMPLETE THE DRAWING

You can also make a combination of drawings, or a composition, out of the lines.

EXAMPLE

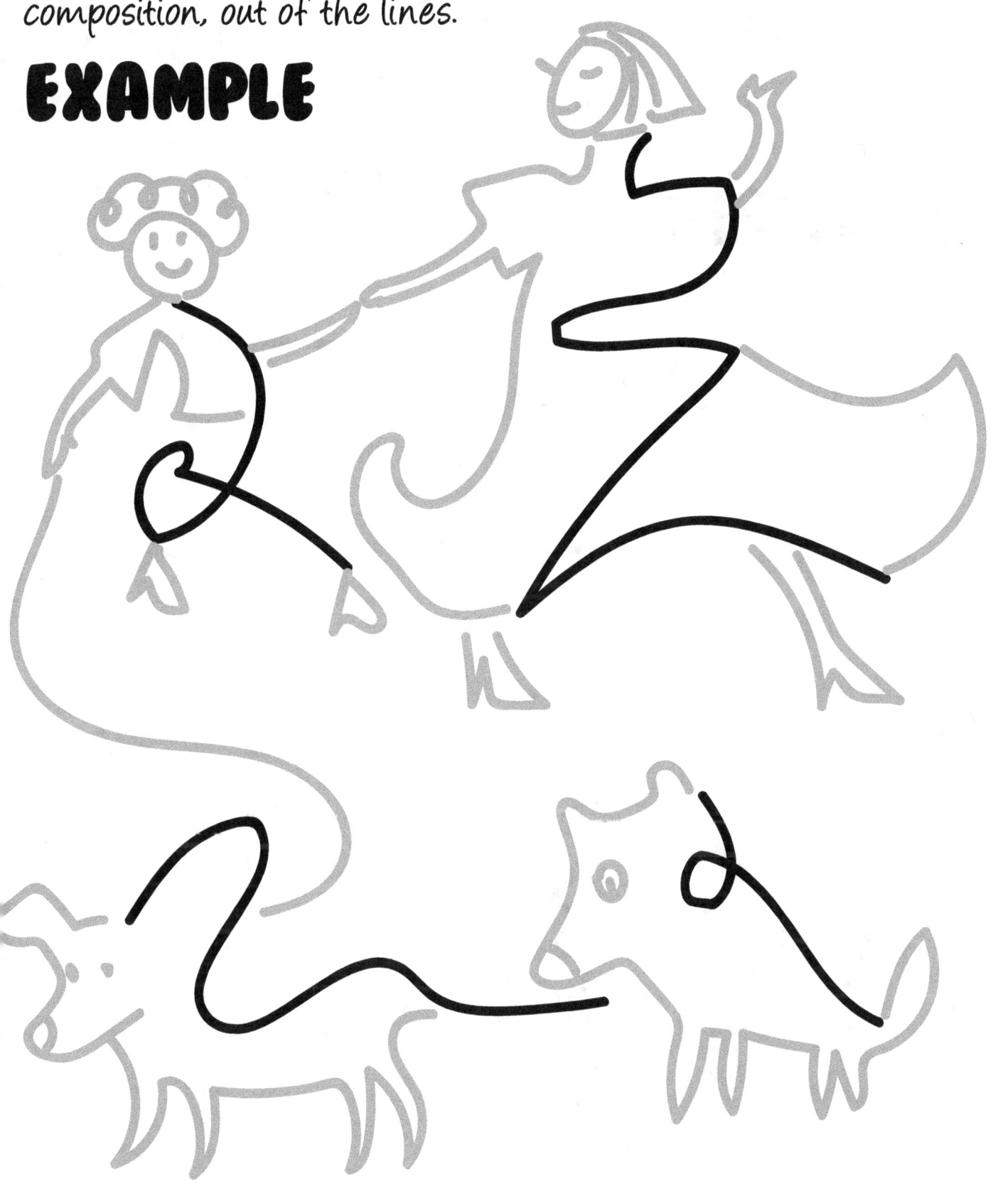

COMPLETE THE DRAWING

You can turn the page in different directions to see different objects! The same squiggly can be made into different things!

EXAMPLE

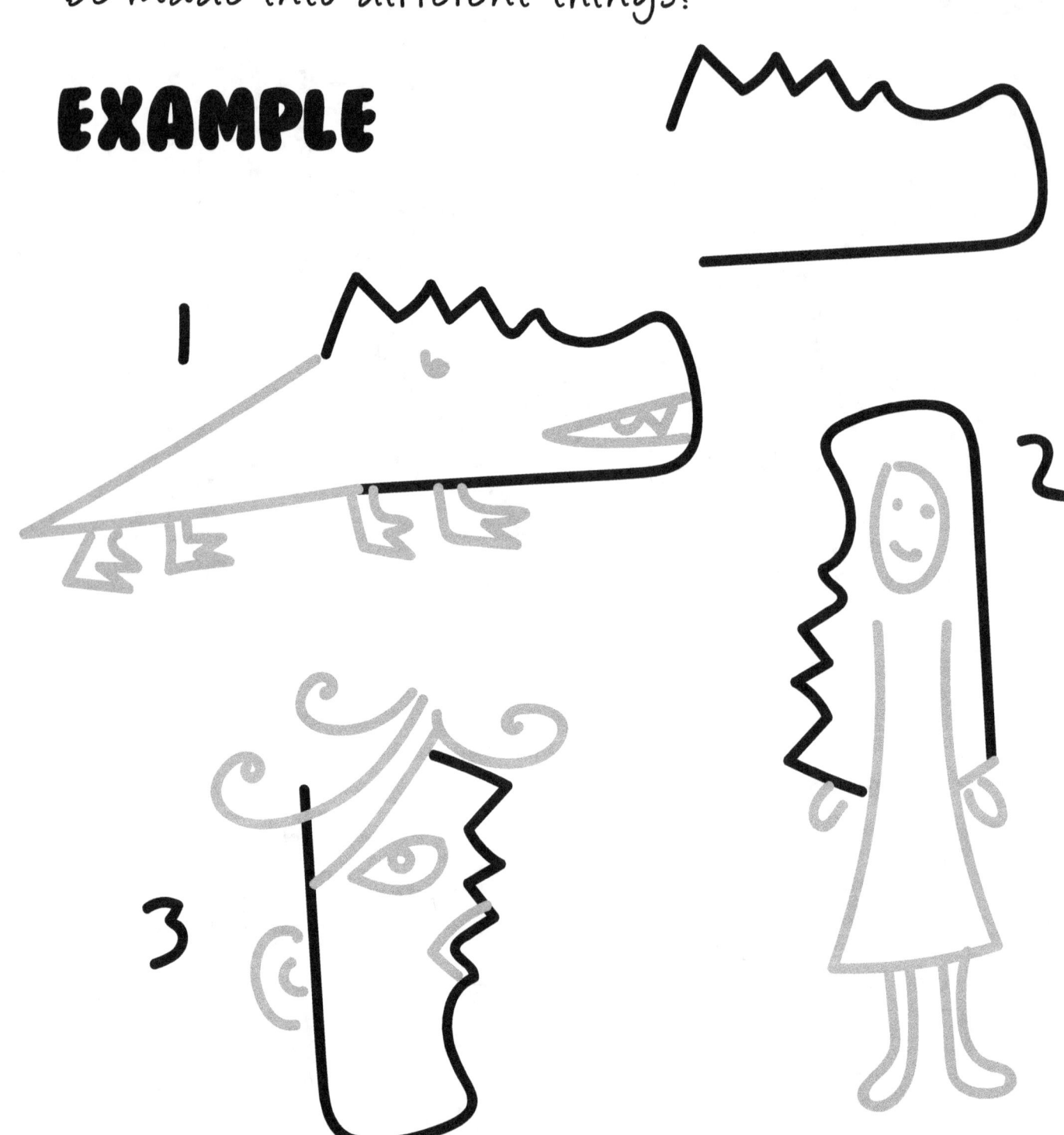

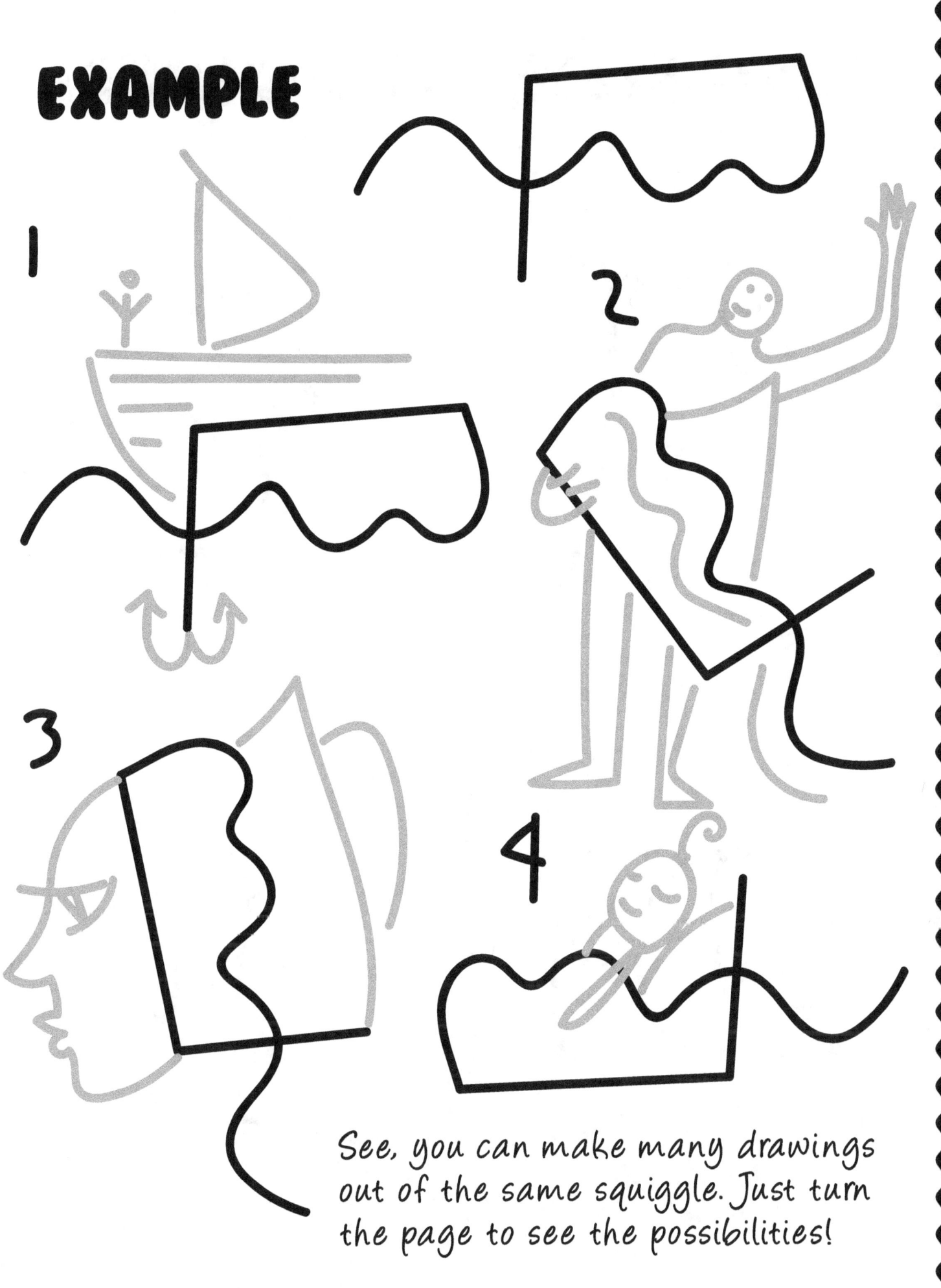

COMPLETE THE DRAWING

COMPLETE THE DRAWING

COMPLETE THE DRAWING

COMPLETE THE DRAWING

COMPLETE THE DRAWING

COMPLETE THE DRAWING

COMPLETE THE DRAWING

COMPLETE THE DRAWING

COMPLETE THE DRAWING

COMPLETE THE DRAWING

COMPLETE THE DRAWING

COMPLETE THE DRAWING

COMPLETE THE DRAWING

COMPLETE THE DRAWING

COMPLETE THE DRAWING

COMPLETE THE DRAWING

COMPLETE THE DRAWING

COMPLETE THE DRAWING

COMPLETE THE DRAWING

COMPLETE THE DRAWING

COMPLETE THE DRAWING

COMPLETE THE DRAWING

COMPLETE THE DRAWING

COMPLETE THE DRAWING

COMPLETE THE DRAWING

COMPLETE THE DRAWING

COMPLETE THE DRAWING

COMPLETE THE DRAWING

COMPLETE THE DRAWING

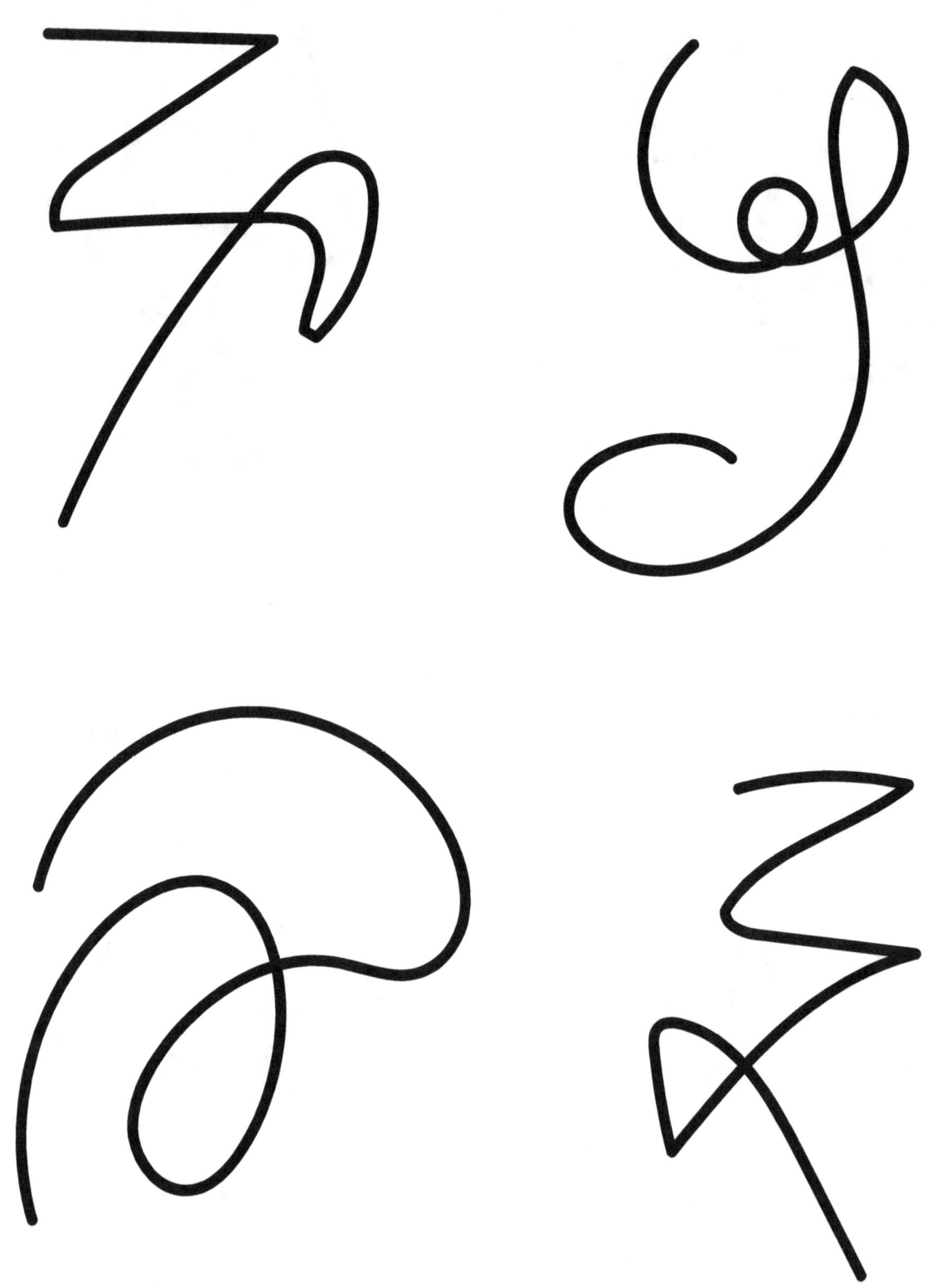

COMPLETE THE DRAWING

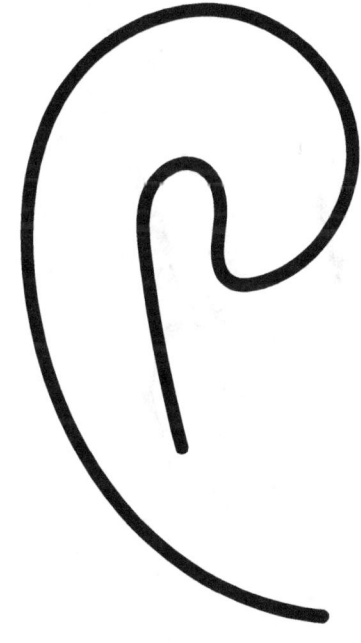

COMPLETE THE DRAWING

COMPLETE THE DRAWING

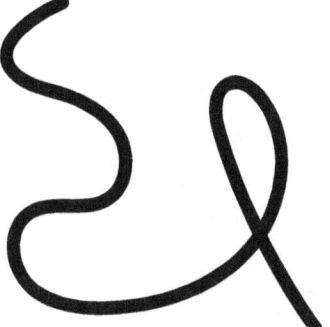

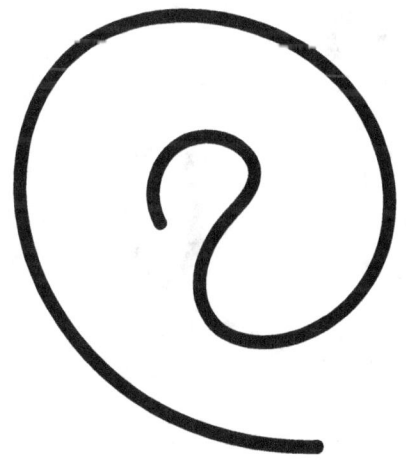

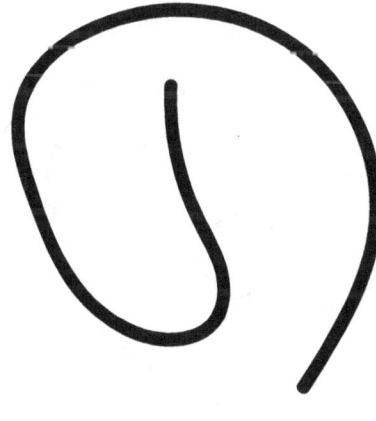

COMPLETE THE DRAWING

COMPLETE THE DRAWING

COMPLETE THE DRAWING

COMPLETE THE DRAWING

COMPLETE THE DRAWING

COMPLETE THE DRAWING

COMPLETE THE DRAWING

COMPLETE THE DRAWING

COMPLETE THE DRAWING

COMPLETE THE DRAWING

COMPLETE THE DRAWING

COMPLETE THE DRAWING

COMPLETE THE DRAWING

COMPLETE THE DRAWING

COMPLETE THE DRAWING

COMPLETE THE DRAWING

COMPLETE THE DRAWING

COMPLETE THE DRAWING

COMPLETE THE DRAWING

COMPLETE THE DRAWING

COMPLETE THE DRAWING

COMPLETE THE DRAWING

COMPLETE THE DRAWING

COMPLETE THE DRAWING

COMPLETE THE DRAWING

COMPLETE THE DRAWING

COMPLETE THE DRAWING

COMPLETE THE DRAWING

COMPLETE THE DRAWING

COMPLETE THE DRAWING

COMPLETE THE DRAWING

COMPLETE THE DRAWING

COMPLETE THE DRAWING

COMPLETE THE DRAWING

COMPLETE THE DRAWING

COMPLETE THE DRAWING

COMPLETE THE DRAWING

COMPLETE THE DRAWING

COMPLETE THE DRAWING

COMPLETE THE DRAWING

COMPLETE THE DRAWING

COMPLETE THE DRAWING

COMPLETE THE DRAWING

COMPLETE THE DRAWING

COMPLETE THE DRAWING

COMPLETE THE DRAWING

COMPLETE THE DRAWING

COMPLETE THE DRAWING

COMPLETE THE DRAWING

COMPLETE THE DRAWING

COMPLETE THE DRAWING

COMPLETE THE DRAWING

COMPLETE THE DRAWING

COMPLETE THE DRAWING

COMPLETE THE DRAWING

COMPLETE THE DRAWING

COMPLETE THE DRAWING

COMPLETE THE DRAWING

COMPLETE THE DRAWING

COMPLETE THE DRAWING

About the Artist

Anna Nadler is an illustrator, graphic designer and author, who lives and works in New York City. She loves drawing fashion, people, animals and architecture, as well as creating unique logo designs for various companies from around the world. You can view more of her work on her website - www.annanadler.com and on social media platforms. You can also find many of her original art books in her Amazon.com book store, where she is always adding new journals, diaries, notebooks, children's books, gift books, planners and coloring books. In her free time Anna loves traveling, singing jazz songs and spending quality time with her friends and family.

Thank you for coloring this book!
If you enjoyed it, please leave a review
on Amazon.com!

www.ingramcontent.com/pod-product-compliance
Lightning Source LLC
Chambersburg PA
CBHW081447220526
45466CB00008B/2540